An Introduction to

'Victorian' Genre Painting

from Wilkie to Frith

An Introduction to

'Victorian' Genre Painting

from Wilkie to Frith

Lionel Lambourne

Assistant Keeper, Department of Paintings
Victoria & Albert Museum

LONDON: HER MAJESTY'S STATIONERY OFFICE

Edited by Anthony Burton
Designed by Andrew Shoolbred
to a series design by Humphrey Stone
Printed in Great Britain by W. S. Cowell Limited, Ipswich

ISBN 0 11 290379 7
Dd 696400 C46

Unless otherwise indicated all pictures are oil on canvas.

Genre

Princess Victoria came to the throne in 1837 and remained Queen until the end of the century. Her long reign has made the adjective 'Victorian' a convenient, but at times misleading, descriptive term. When attached to the words 'genre painting', it is almost invariably accompanied by another adjective, 'sentimental'. The phrase 'sentimental Victorian genre painting' flows glibly off the tongue or pen, conjuring up immediate visual impressions of pretty girls posting love letters in hollow trees, kittens playing with balls of wool, fathers being led from the pub by tearful children, and Grandmammas celebrating their birthdays, images which derive from the popular art-forms of Baxter prints, Christmas cards, Temperance lantern slides and German chromolithographs.

When the actual paintings of the period are examined our findings are rather different. The first great flowering of nineteenth-century genre painting took place in the reigns of George IV and William IV, before Victoria came to the throne. Most of the genre artists whom we think of as typically Victorian – Mulready, Landseer, Webster, C. R. Leslie – had established their reputations long before 1837, and Wilkie, the first great master of the nineteenth-century genre school, died in 1841. Their range of subject-matter was developed from the tradition of rural painting established in the Dutch school since the seventeenth century.

As the century progressed works of a different character were created, beginning with great cross-sections of urban life at the sea-side resort, race-track or railway station, by W. P. Frith. Later, magazines like *The Graphic*, in the 1880's, and the paintings of the Newlyn School, added a new note of social realism to the scene. This formed an effective contrast to the glittering sophistication of the fashionable world portrayed by J. J. Tissot, the Venetian caprices of Sir Luke Fildes, the 'Forsythian' dramas of Sir W. Q. Orchardson, and the painstaking historicism of the St John's Wood Clique.

This essay will, however, be concerned to chart the course of genre painting from Sir David Wilkie's *Chelsea Pensioners Reading the Gazette of the Battle of Waterloo* of 1822 to W. P. Frith's *Derby Day* of 1858: two works which gained the ultimate accolade of popular acclaim at the Royal Academy, the erection of a protective bar before them to protect them from an over-appreciative audience.

The word 'genre' is a good example of the type of art-historical term from which quite well informed people back away in alarm. Like many arcane fine-art words it seems calculated to make uninitiated people feel they could never hope to understand a subject with such a strange name.

It is particularly ironic that this should be so, since the word, derived from the French collective noun for people, *les gens,* means, when added to 'pictures' in the phrase '*tableaux des genres*', literally, pictures of people; the portrayal of scenes from ordinary life, often with a narrative or anecdotal element.

Artists have painted such pictures since Egyptian times by portraying people in universally understood relationships, for example young lovers disturbed by an intruder, an idle servant and a stern master, or a rich man and a beggar. The inclination to see and hear such anecdotes lies deep in human nature, although different ages satisfy it in various artistic ways. In our own time we listen to, or watch, the daily anecdote of radio and television 'soap operas' like *The Archers* or *Coronation Street*. These provide us with our everyday story of country folk, or city street; stories with readily identifiable human types in situations to which it is easy for many millions of people to relate. Earlier generations found similar

pleasure in novels appearing in serial form and in genre paintings.

All these forms of art have in common the need to introduce a strong dramatic incident – a tableau of human action arrested at a striking moment and portraying a readily understood situation.

In the Victorian age paintings of such incidents were of immense public interest, both when they appeared on the walls of the Royal Academy and when they were seen in the form of engravings. The introduction of steel plates in the 1820's made very large editions of such prints possible, and an artist's public could be numbered in many thousands, for by 1840 editions of 20,000 or 30,000 prints after a popular painting were being produced.

This essay tells the story behind some of the most popular of these paintings, but before examining them in detail, it is necessary to look at some earlier precursors of nineteenth-century genre subjects.

The Precursors

The greatest of all genre painters, Pieter Brueghel (c.1527–1569) worked in the sixteenth century in Antwerp, and his treatments of such simple themes as children's games and village weddings are among the most profound of all human artistic achievements. His pictures established a long tradition of similar works, and the picture-loving Dutch bour-

geoisie of the seventeenth century delighted in the convivial scenes of Jan Steen (1626–1679) and David Teniers (1610–1690), the daily tragi-comedies of the master-servant relationship to be found in the work of Pieter de Hooch, and the low-life glimpses of 'boors' carousing in the powerful small-scale panels of Adriaen Brouwer (c.1605–1638) and Adriaen van Ostade (1610–1684).

But although the seventeenth century in the Low Countries saw the great flowering of genre painting, it also saw the development throughout Europe of academies, and the establishment of the pecking order of High Art, which placed religious, history and portrait painting at a far more exalted level in the hierarchy of styles than the lowlier arts of landscape, genre and animal painting.

Artists like Jean Baptiste Greuze (1725–1805) working in the fervid atmosphere of pre-revolutionary France, alert to the ground-swell of enthusiasm for the concept of 'Natural Man' expounded in the works of Jean Jacques Rousseau, but also conscious of the low esteem given to genre works in the Salon, felt the necessity to elevate genre paintings by introducing lofty sentiments. Greuze worked with conventions of gesture and expression that were common to many forms of mimetic art, both popular and 'high brow', and his pictures had an international audience, well beyond the frontiers of

1

PLATE 1
Jan Steen
The Dissolute Household or
Intemperance and the Juvenile Depredators
Signed Jan Steen
30½ × 34½ in (76 × 86 cms)
WM 1514–1948
Apsley House

PLATE 2
Francis Hayman R.A. (1708–1776)
The Milkmaid's Garland or
The Humours of May Day
54½ × 94½ in (136 × 236 cms)
P 12–1947
Bought with aid of the National
Arts Collections Fund

France. They connect closely with the genre school in England, and his figures' rhetorical poses still find an echo today in official Soviet art.

Both the genre tradition of the Low Countries and the work of Greuze were long to play influential roles in the development of narrative painting in England in the early nineteenth century. In purely English terms, however, the roots of genre painting grow from the work of William Hogarth. Through the medium of engravings the powerful stories depicted in *The Rake's Progress*, *Marriage à la Mode* and *The Idle and Industrious Apprentices* became as well known to the English public as the novels by Henry Fielding and Tobias Smollett which they resemble so closely. Hogarth's works, dramatic, small in size, at once both satirical and compassionate, established a uniquely British style of genre painting. They became an unconscious part of the public's visual vocabulary, and, long after his death, provided, as he would have wished, an alternative direction for both artists and public to the sublime and the picturesque.

Hogarth's stage was, however, an essentially urban one. Throughout the eighteenth century, as the capital grew in size so did the nostalgia among sophisticated Londoners for the joys of a rural Arcadia. Hayman's decorations for the supper boxes at Ranelagh, the famous London pleasure garden, which portrayed boys sliding on the ice and other rural games, and the charming freshness of milkmaids on May Day (PLATE 2), mark the first phase in the characteristic English development of the 'fancy picture', of which Thomas Gainsborough was the greatest exponent (PLATE 3). Such pastoral themes were to prove hardy perennials in the English genre tradition.

As the eighteenth century came to a close, a new note was introduced into pastoral painting by the work of artists like Francis Wheatley, famed for his *Cries of London* (the classic example of '*Rus in Urbe*' sentiment), J. C. Ibbottson, Henry Singleton and W. R. Bigg. The title alone of Bigg's *Cottager at His Door* (PLATE 4) might lead one to expect a fancy subject similar to Gainsborough's frequent treatment of this theme, but the painting's uncompromising note of realism reminds us of the actualities of rural life behind the idyllic Arcadia of the pastoral painters. These qualities are found to an even greater degree in the work of George Morland (1763–1804).

Morland's erratic genius has been long neglected as a subject for serious study. In his own lifetime he became a legendary figure, the public delighting in seeing him as an intemperate genius, always in debt, who miraculously never lost a happy facility for turning out pictorial combinations of pigs and pretty girls. In fact, a closer study of his work reveals both a suprisingly wide acquaintance with contemporary

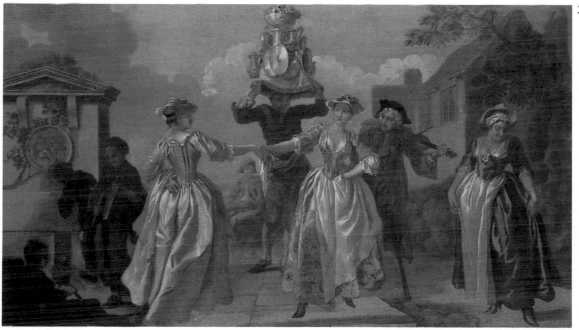

2

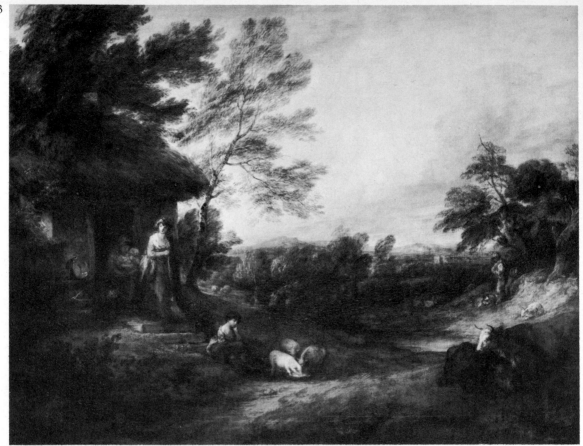

PLATE 3
Thomas Gainsborough R.A. (1727–1788)
The Cottage Door
39 × 49 in (98 × 123 cms)
Gainsborough in this picture has combined two of his
most successful genre themes in the depiction of two
girls, one at the cottage door with a broom, and the
other feeding pigs.
On loan to the Victoria and Albert Museum.

PLATE 4
William Redmore Bigg R.A. (1755–1828)
Cottager at His Door
Signed W. R. Bigg 1793
24 × 29 in (60 × 72 cms)
198–1885

PLATE 5
George Morland
*The Reckoning – A Farmer Paying the Ostler and Pot-boy of
an Inn*
Signed G. Morland
29 × 39 in (72 × 97 cms)
F.A.237
Given by F. Peel Round

artistic theories and literature (he illustrated Vol-
taire), and a considerable knowledge of the Dutch
School acquired during his apprenticeship to his
father, Henry Robert Morland (1712–1797), an in-
teresting artist who specialised in half-length por-
traits with dramatic light effects. Thus equipped,
George Morland was able to give to his chosen rural
themes a surprising strength (PLATE 5). Occasionally,
in a work like *The Fairing* or *Valentine's Day* (PLATE
6), a note of ambiguity is introduced which distin-
guishes the treatment from that of 'Victorian' paint-
ers who sometimes were less subtle and
understanding in their approach.

The work of Bigg and Morland should be seen
against the background of social upheaval in the
Agrarian Revolution of the later eighteenth century.
The rural life they recorded was soon to be affected
also by the remorseless growth of the manufacturing
cities, and a dramatic increase in population. The
middle classes which arose during these difficult
years of economic reconstruction and expansion after
the Napoleonic wars still felt a nostalgia for their

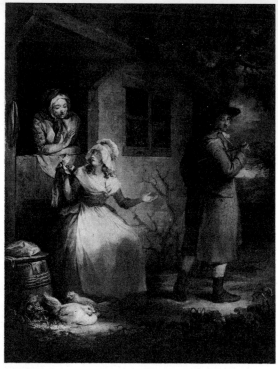

Sir David Wilkie

Wilkie, so admired during his own life time, is to-day, paradoxically, the least known and appreciated by the general public of all the great nineteenth-century British painters. It is over twenty years since the last major exhibition featuring his work was seen in London, and another full-scale show is greatly to be desired; it would demonstrate his superlative powers as a still-life painter, and his brilliant handling of chalk and wash in the many drawings made as studies for his large-scale compositions.

He was born at Cutts, Fife, in 1785, the son of a Presbyterian minister. As a boy he diligently studied the engravings of Ostade and Teniers, and their influence can clearly be seen in much of his precociously brilliant early work. His *Pitlessie Fair*, painted when he was nineteen years of age and inspired by visits to a local fair, is a variation on Teniers, although the colour range shows that he knew the Dutch prototype through engravings rather than from the original. Encouraged by the sale of this work Wilkie settled in London in 1804, where he found patrons eager to buy and commission his animated scenes of Scottish life, full of anecdote and humour, such as his *Village Politicians* of 1806: a contemporary variation on a seventeenth-century Dutch theme. The Prince Regent himself purchased two important early works for the Royal Collection, *The Penny Wedding* and *Blind Man's Buff*, the latter work of 1812, being still indebted to Adriaen van Ostade in conception and handling, though also showing a marked debt to the French tradition. While Wilkie gained his reputation for painting large groups of animated figures, as these titles suggest, he also excelled in small cabinet-sized pictures, like *The Letter of Introduction*, 1813, (a study for which is in the Victoria and Albert Museum) and *Duncan Gray, The Refusal* of 1814 (PLATE 7). This painting was inspired by Robert Burns's poem about the wooing by Duncan Gray of the 'Haughty Hizzie' Meg . . . 'deaf as Ailsa Crag'. Wilkie's sister sat as the model for Meg, his friend the painter William Mulready for Duncan Gray and Mulready's parents as Meg's mother and father.

The culmination of Wilkie's early success was marked by the commission he received in 1816 from the Duke of Wellington for the painting *Chelsea Pensioners Reading the Gazette of the Battle of Waterloo* (PLATE 8). The Duke had originally suggested a small picture on the theme of 'British Soldiers Regaling at Chelsea', and it was Wilkie's idea to introduce the dramatic event of the arrival of the news of the great

rural roots, which was to be reflected in the paintings which they purchased with the fruits of their new-found prosperity. In many ways their taste in pictures resembled that of the wealthy burghers and merchants of seventeenth-century Holland, for their houses were not palaces and they naturally inclined towards small and unpretentious works, rather than the grand portraiture traditionally commissioned by the aristocracy. The Dutch School, long neglected because of the demand for Italian old masters, became popular, gaining ground in the estimation of the connoisseurs. The turmoil which followed the French Revolution had broken up many of the great collections of Europe, and the enterprise of dealers, together with the eloquence of the auctioneer James Christie, led to a number of major Dutch landscapes and genre paintings entering English collections at various social levels. The Prince Regent, the Duke of Wellington and Sir Robert Peel all acquired notable examples of the work of such artists as Jan Steen, Ostade, Teniers, De Hooch, Metsu, Cuyp and Hobbema.

This growing love of Dutch painting naturally found itself reflected in the work of contemporary artists. Foremost among them was the remarkable figure of Sir David Wilkie (1785–1841).

PLATE 6
George Morland
Johnny Going to the Fair or *The Valentine*
18 × 13½ in (45 × 34 cms)
541–1882
Jones Bequest

PLATE 7
Sir David Wilkie
The Refusal
from Robert Burns 'Song of Duncan Gray'
Exhibited R.A. 1814
24¾ × 20¼ in (62 × 51 cms)
F.A.226
Sheepshanks Gift

PLATE 8
Sir David Wilkie
Chelsea Pensioners Reading the Gazette of the Battle of Waterloo.
Signed and dated Wilkie, 1822
Exhibited R.A. 1822
36½ × 60½ in (91 × 151 cms)
WM 1469–1948
The painting subsequently inspired a companion picture
by John Burnet (1784–1868) of *The Greenwhich Pensioners*
of 1835, also at Apsley House.

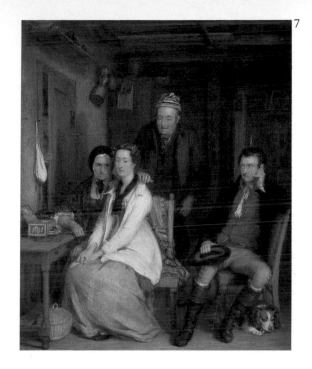

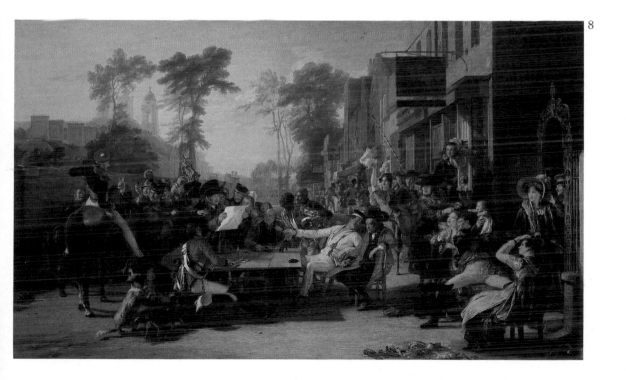

British victory. Wilkie took immense pains with the many portraits which made up the crowded scene, designing a box in which he experimented with small model figures in order to perfect the composition, and making many sketches. The work took five years to complete, and Wilkie asked the then huge price of 1,000 guineas for it to the chagrin of the Duke, who insisted on paying for it in bank notes rather than by cheque, in order that the clerk at his bank, Coutts's, should not think him a fool!

When the painting was shown at the Royal Academy in 1822 it had an immense success: high and low flocking to see it, enraptured by its patriotic subject. So great were the crowds that, for the first time in the history of the Royal Academy, a protective barrier had to be erected in order to protect the work. This barrier was not to reappear until Frith's equally great success with *Derby Day* in 1858.

Wilkie's later visit to Spain, where he became greatly influenced by the paintings of Velasquez, and his tragic early death from fever while returning from the Holy Land, fall outside the scope of the present essay. His immense early success as a painter was to establish firmly the popularity of genre painting, and set the pace for further developments in the field throughout the century. For, as he wrote in his *Remarks on Painting*, 'the taste for art in our isle is of a domestic rather than a historical character. A fine picture is one of our household gods, and kept for private worship: it is an everyday companion'. Wilkie's words provide an apposite description of the small intimate pictures of his friend William Mulready.

Painter and Patron: William Mulready and John Sheepshanks

William Mulready (1786–1863) was born at Ellis in County Clare, but was brought up in Soho in London, and attended the Royal Academy Schools. After a few unsuccessful attempts at painting works in the grand manner with titles like *The Disobedient Prophet*, he turned to landscape, augmenting his income by painting scenery for the theatre, and helping to fill in the vast 'panorama' paintings then in vogue as popular spectacles. Such drudgery must have been a distasteful experience for an artist whose work is always distinguished by its extreme precision of finish. Stimulated probably by his friendship with Wilkie, Mulready began to try his hand in 1808 at genre subjects with pictures like *The Rattle*, an exercise in the manner of Teniers, followed by a large *Carpenter's Shop*, an *Idle Boys*, and *The Fight Inter-*

rupted (PLATE 9) of 1816. It is appropriate that the latter low-key, painterly picture should mark the year of his elevation to the rank of A.R.A., for its subject deals with his lifelong concern, the relationships between youth and age, which he returned to in many of his later works exhibited at the Royal Academy. It was also fitting that the painting should depict a fight, for Mulready was himself a boxer, and had the pugilist's shrewd eye and controlled knowledge of anatomy. Like a boxer he believed in keeping himself constantly in training throughout his career as an artist, and at the age of 74 still practised drawing heads and hands rapidly in pen and ink at a life school, remarking, 'I had lost somewhat of my powers in that way, but I have got it up again: it won't do to let these things go'.

The Victoria and Albert Museum possesses nearly 500 of his drawings from all stages of his career, and 33 oils, about a third of his total output; he was a slow painter, producing only two or three works a year. The reason why this large collection has fortunately remained together lies in the artist's relationship with one of his main patrons, John Sheepshanks, whose energetic connoisseurship assembled the majority of the works which form the theme of this essay. Sheepshanks's achievements as a collector were indeed so important to the whole development of genre painting in England that they must be described more fully.

John Sheepshanks came from a family enriched by the great expansion of the cloth industry at the end of the eighteenth century. Until middle age he remained a partner in the family business at Leeds, but after his father's death he sold up and moved to London. He had already shown an interest in the fine arts (his first collection of engravings is now in the British Museum), and he had bought copies of Italian paintings. The foundation of the National Gallery in 1824 on the basis of the Angerstein collection probably convinced him that there was little he could contribute in the old-master field, but much, on the other hand, to contemporary British art. Accordingly, he decided to found a National Gallery of British Art, and this was put into effect by his gift in 1857 of 233 oil paintings and 298 drawings to the new museum at South Kensington. The gallery thus founded retained its function as the national collection until the Tate Gallery, early in the present century, took over prime responsibility for the representation of the British School.

All this lay in the future when Mulready first became a friend of the collector, almost his exact

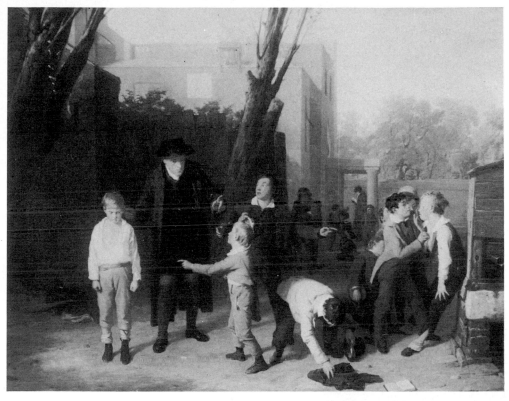

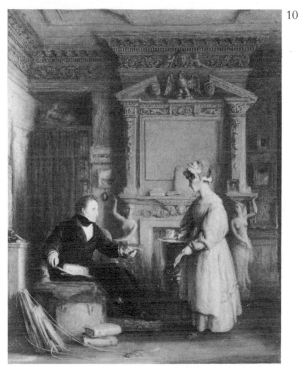

PLATE 9
William Mulready R.A.
The Fight Interrupted
Signed W. Mulready
Exhibited R.A. 1816
28½ × 37 in (71 × 93 cms)
F.A. 139
Sheepshanks Gift

PLATE 10
William Mulready R.A.
John Sheepshanks at His Residence, 172 New Bond Street
20 × 15¾ in (50 × 39 cms)
F.A. 142
Sheepshanks Gift

PLATE 11
William Mulready R.A.
*The Sailing Match – A Woman Urges on a Reluctant
Schoolboy.*
Panel 14 × 12¾ in (34 × 32 cms)
F.A. 147
Sheepshanks Gift
A classic example of the early nineteenth-century artist's
delight in giving innocuous subjects an inspiring moral
flavour. The poor idle boys who attempt to blow their
boat along with a roughly improvised roll of paper have
sent one of their number to fetch a bellows. A wealthy
industrious boy who would like to join in the game is
being 'led from temptation' by his mother or nurse. Such
pictorial allegories have their origins in Dutch
seventeenth-century painting.

PLATE 12
William Mulready R.A.
Brother and Sister or *Pinching the Ear*
Signed W. Mulready 1836
Panel 12 × 9¾ in (30 × 24 cms)
F.A.144
Sheepshanks Gift

11

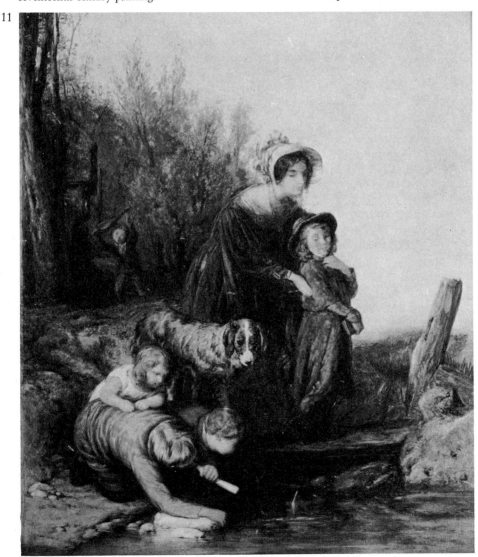

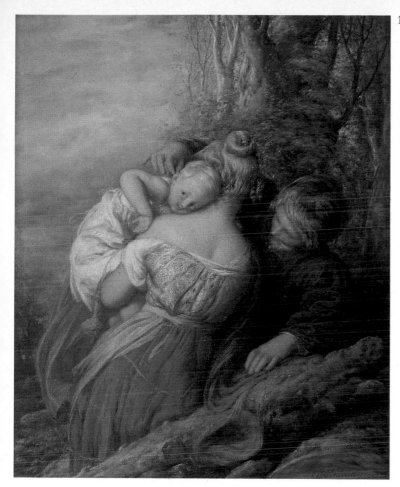

12

contemporary, who was to buy or commission some of his finest works. We gain a vivid impression of how Sheepshanks would have liked to be remembered from Mulready's portrait of 1832, showing the collector looking at a portfolio of drawings in his house, 172 New Bond Street, while attended by a maid (PLATE 10). In reality, however, Sheepshanks was a slightly more eccentric figure and many artists' memoirs of the period record his unexpected vacillations between frugality and generosity. He was a lifelong bachelor, with a lively sense of self-mockery; 'Is there,' he asked, 'a lady in the world who would like to be called Mrs Sheepshanks?' In later life he lived at Blackheath, cultivated roses, collected antiquarian books, and every Wednesday evening entertained a wide circle of contemporary painters.

Sheepshanks's achievement was a major one, and his collection today provides us with a microcosm of early Victorian taste. Although his main love was

genre painting – he owned fine works by Sir David Wilkie, C. R. Leslie, Thomas Webster, and no less than 16 Landseers, as well as his unique collection of Mulreadys – he also acquired fine examples of the landscapes of Turner and Constable. While naturally keen on a bargain when the opportunity arose, he was also willing to commission work at high prices. For Mulready, with his slow methods of work, such a commission as the £1,050 for *Choosing the Wedding Gown* (PLATE 13) in 1846 must have been providential, for it enabled him to concentrate, as he loved to do, on perfecting the subtle richness of his colouring, and the painting when exhibited at the Royal Academy proved to be one of his most acclaimed works.

It was with small pictures like these, which fulfilled Wilkie's dictum, that Mulready enjoyed his greatest success. A letter from a prospective client to the artist is most revealing in this respect, asking

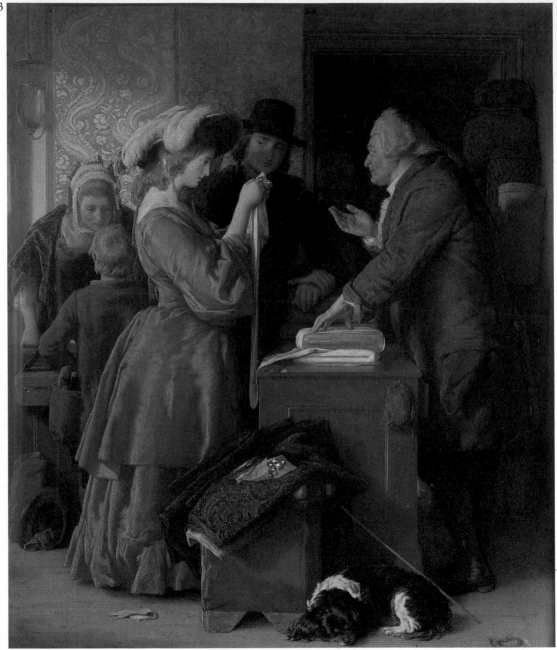

PLATE 13
William Mulready R.A.
Choosing the Wedding Gown
from Oliver Goldsmith, *The Vicar of Wakefield*
Exhibited R.A. 1846
Panel, 21 × 17¾ in (52.5 × 44 cms)
F.A. 145
Sheepshanks Gift

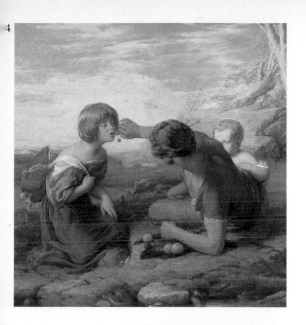

4

him 'to let me know the price of the smallest picture you paint'. But he also at times essayed larger compositions, like his elaborate attempt to provide pictorial equivalents for Jacques's speech on the seven ages of man in Shakespeare's *As You Like It* (PLATE 17). Although this picture was regarded by Sheepshanks, who commissioned it in 1838, as the crown of his Mulready collection, it is difficult not to agree with Ruskin's criticism that 'this subject cannot be painted'.

Mulready had no avant-garde theories, but the Pre-Raphaelites greatly admired his daring use of sonorous, vibrant colour, in works like *Open Your Mouth and Shut Your Eyes* of 1838 (PLATE 14), and *The Sonnet* of 1839 (PLATE 15), and learned much from him as a teacher at the Royal Academy. Ironically, the portrayal of subjects from contemporary life, a course warmly advocated by the Pre-Raphaelites, was in practice more frequently and successfully carried out by Mulready, although Ruskin criticised his subject-matter as being 'entirely uninteresting'.

His choice of themes such as youth and age or young love and childhood had, despite Ruskin's strictures, considerable influence on the later course of genre painting in the early nineteenth century, particularly on the work of the Cranbrook Colony. But before examining their productions, it is rewarding to see how the popular and recurrent theme of childhood was treated by Mulready's contemporary William Collins (1787–1847), and some other independent artists of that time.

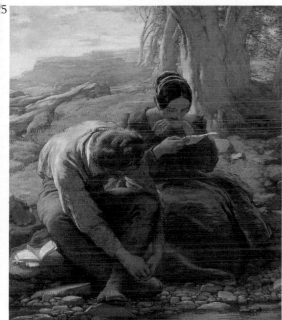

5

PLATE 14
William Mulready R.A.
Open Your Mouth and Shut Your Eyes
Painted 1838
Exhibited R.A. 1839
Panel 12½ × 12 in (31 × 30 cms)
F.A. 144
Sheepshanks Gift

PLATE 15
William Mulready R.A.
The Sonnet
Exhibited R.A. 1839
Panel 14 × 12 in (35 × 30 cms)
F.A. 146
Sheepshanks Gift

17

16

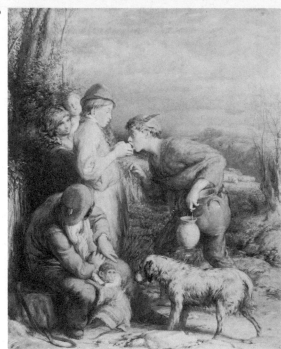

PLATE 16
William Mulready R.A.
Giving a Bite – One Country Lad Compels Another to Give Him a Bite from His Apple
Signed W. Mulready 1834
Exhibited R.A. 1836
Panel 20 × 15½ in (50 × 39 cms)
F.A. 140
Sheepshanks Gift

PLATE 17
William Mulready R.A.
The Seven Ages of Man
from Shakespeare, *As You Like It*, Act II scene vii
Exhibited R.A. 1838
35½ × 45 in (89 × 113 cms)
F.A. 138
Sheepshanks Gift

PLATE 18
William Collins R.A. (1788–1847)
The Stray Kitten
Signed W. Collins 1835
Panel 18 × 24 in (45 × 60 cms)
F.A.29
Sheepshanks Gift

17

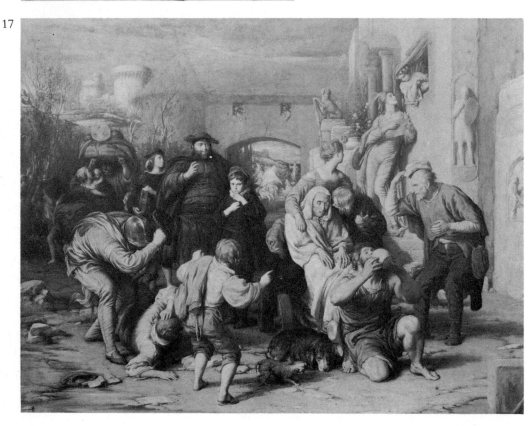

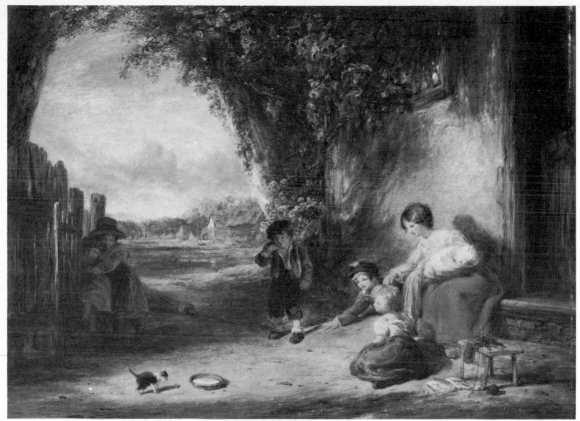

Recurrent Themes: Childhood

Social attitudes towards children and childhood underwent slow but considerable changes during the early nineteenth century. The evils of child labour in the factories and mines, and the climbing boys employed by chimney sweeps, evoked both the compassionate sympathy of writers like Charles Dickens and Charles Kingsley, and the practical legislative measures introduced by Lord Shaftesbury. At the other end of the social scale the ferocious cruelty and inefficiency of the English public-school system led to the reform movement inaugurated by Dr Arnold at Rugby, and chronicled by Thomas Hughes and Dean Stanley.

The criticisms of 'sentimentality' which can be levelled at these literary depictions of childhood are also invariably applied to the contemporary paintings of childhood themes. In both cases such criticisms are over-simplistic, for it was precisely in their tendency to sentimentalise, to demand the response of compassion, that such works afforded powerful inducements to public humanitarianism.

William Collins was one of the most successful artists to deal consistently with the theme of childhood. As a boy he had watched George Morland at work (his father wrote a biography of him), and his own subjects were also chiefly taken from English country life, often combining a landscape setting with an incident involving children, as in *The Stray Kitten*, (PLATE 18). Unlike his contemporary Mulready, however, Collins did not use children as a subject for adult humour, did not laugh *at* their predicament in arriving late for school (as did Mulready in his *The Last In*, 1838, Tate Gallery), but depicted each subject sympathetically, on its own terms, with no adult condescension. This may perhaps be due to Collins's contact with Coleridge and Wordsworth while staying at Sir George Beaumont's country house at Coleorton in 1818, for certainly there is something Wordsworthian about the lyrical quality of such a work as *Happy as a King*, 1833 (National Gallery), showing poor children swinging on a gate.

Collins's work is well represented in the Sheep-

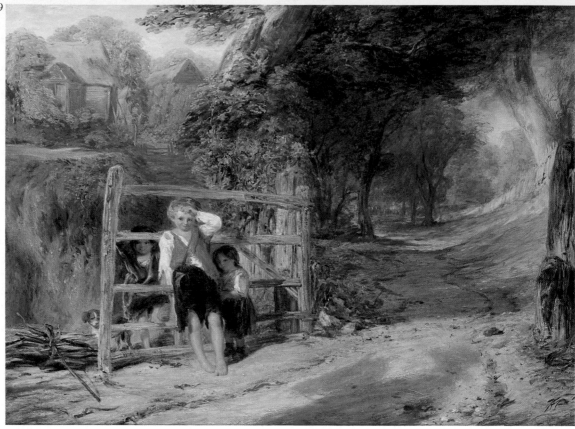

shanks collection with a fine example of a favourite theme of the artist, the children of fishermen working by the sea-shore, in *Seaford, Coast of Sussex*, 1844. Also in the collection is his most well-known painting, *Rustic Civility* (PLATE 19); a second version of the original painting bought at the Royal Academy in 1832 by the Duke of Devonshire. The painting at first appears to be simply a 'puzzle picture' of a type always popular at the Royal Academy. Although its composition is certainly masterly, the social issues it raises are both complex and thought-provoking, and make it one of the most interesting pictures of the English genre school. Some bare-footed children, who have been gathering sticks, nervously hold open a gate for a rider of rank whose shadow alone is seen, cast in the foreground of the picture. The eldest boy timidly 'pulls his forelock' in obeisance to the rider, and thus indirectly at each viewer who stands in front of the picture★.

Another rewarding painter of childhood, who approached his subject with a remarkably objective

PLATE 19
William Collins R.A.
Rustic Civility
Signed W. Collins 1837
Panel 18 × 24 in (45 × 60 cms)
F.A.27
Sheepshanks Gift

★It is interesting to note that while working for five years in the Education Department of the Victoria and Albert Museum I have shown this painting to many hundreds of children of the same age as those depicted by Collins. When asked to explain what the boy is doing, and why he is touching his head, the invariable initial reply is 'he's hot'; the master–servant connotation of the situation, and the picture's title, both prove puzzling concepts for modern children to grasp.

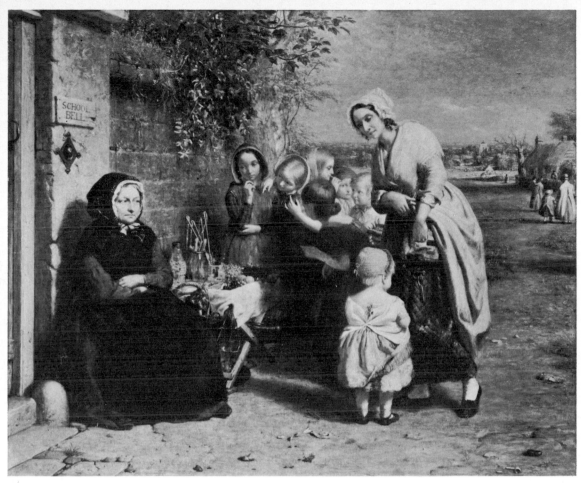

PLATE 20
George Smith
Temptation – A Fruit Stall
Signed G.S. 1850
Panel 25 × 30 in (62 × 75 cms)
F.A.186
Sheepshanks Gift

eye, was George Smith (1829–1901). In his charming study *Temptation—A Fruit Stall* of 1850 (PLATE 20), besides showing boiled sweets, tops and whips, and luscious fruit guarded by the old stall-holder and her dog hidden under the table, Smith also depicts two sturdy little boys, dressed in frocks—the usual dress for infants of both sexes. Donning trousers, or 'being breeched', in the mid-nineteenth century was a great event for a small boy, signalling the end of infancy and such innocent pleasures as gathering flowers; the subject of another painting by Smith of 1851 (PLATE 21). Among the many artists who also treated this theme, always one of the most appealing moments of infancy to witness, was John Linnell, in a small idyllic painting entitled *The Wild Flower Gatherers* of 1831 (PLATE 22). W. F. Witherington's *The Hop Garland* (see front cover), painted in 1834, shares the charm of these works, and serves as a reminder that

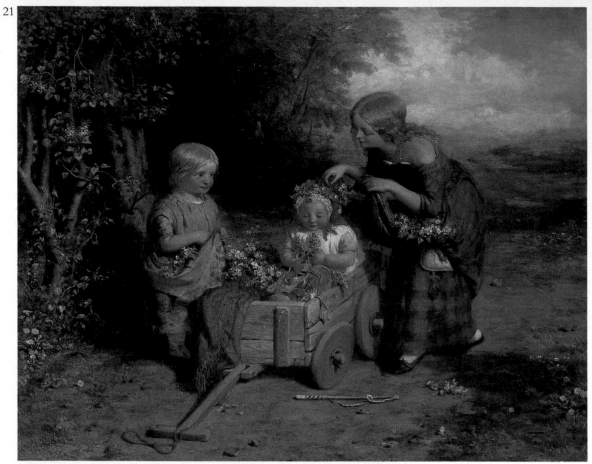

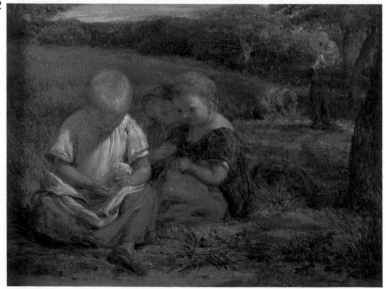

PLATE 21
George Smith
Children Gathering Wild Flowers
Signed G. Smith 1851
Panel 18 × 22 in (45 × 55 cms)
F.A.187
Sheepshanks Gift

PLATE 22
John Linnell (1792–1882)
The Wild Flower Gatherers
Signed J. Linnell 1831
Panel 6¼ × 8¼ in (16 × 21 cms)
F.A.133
Sheepshanks Gift

PLATE 23
Thomas Webster R.A.
The Village Choir
Exhibited R.A. 1847
Panel 23¾ × 36 in (59 × 90 cms)
F.A.222
Sheepshanks Gift

hop-picking was, until comparatively recent times, the only summer holiday available to many poor London children who left their homes in the East End to pick hops in the Kent countryside. This subject was also to be treated by Thomas Webster, the leader of the Cranbrook Colony in Kent, whose works closely reflected the ordinary life of the area.

Thomas Webster and the Cranbrook Colony
The Cranbrook Colony was a gathering of close friends and relatives who, from the mid 1840's, settled in, or near, the village of Cranbrook in Kent. Unlike their immediate contemporaries, the Pre-Raphaelite Brotherhood, the group had no intellectual platform but shared a mutual interest in themes of rural life and childhood.

Thomas Webster (1800–1886), the eldest member of the group, was seen as something of a father-figure by the other members. His most famous picture, *The Village Choir*, 1847 (PLATE 23), was painted not in Kent, but at the still standing Bow Brickhill Church, near Woburn in Bedfordshire. The work, which shows identifiable portraits of village worthies in the band and the choir, inevitably reminds us of the characters in Thomas Hardy's first successful novel *Under the Greenwood Tree* (1872), which deals

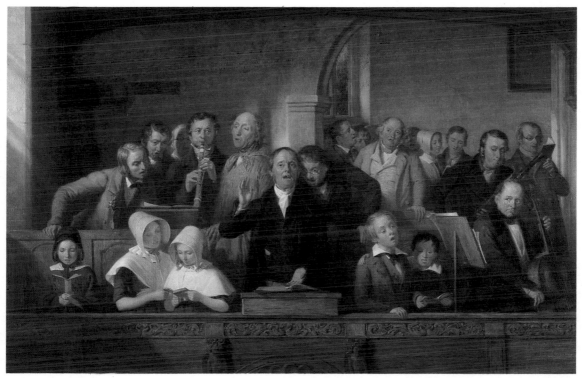

24

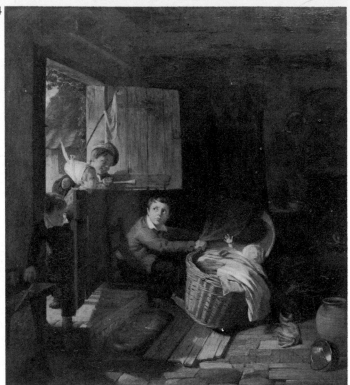

PLATE 24
Thomas Webster R.A.
Beating for Recruits
Signed T. Webster
Panel 17½ × 15½ in (44 × 39 cms)
536–1882
Jones Bequest

PLATE 25
Thomas Webster R.A.
Sickness and Health
Signed T. Webster 1843
Exhibited R.A. 1843
Panel 20 × 32 in (50 × 75 cms)
F.A.219
Sheepshanks Gift

PLATE 26
Frederick Daniel Hardy
Playing at Doctors
Signed F. D. Hardy 1863
17½ × 14 in (44 × 35 cms)
1035–1886

25

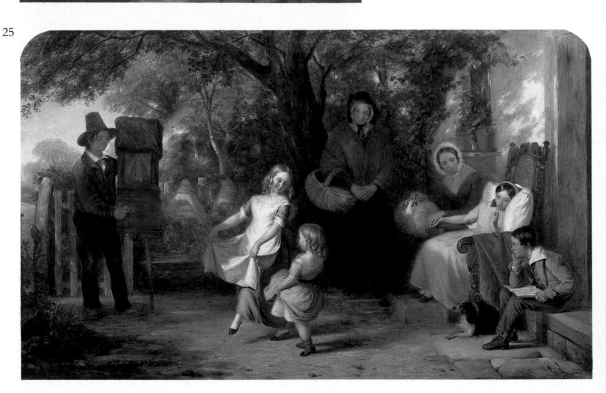

with the same theme – the close-knit bands of village musicians whose old-fashioned instruments gave place in the high Victorian era to the new fangled church organs and harmoniums.

Webster achieved recognition in the 1820s with paintings of children at play, and for fifty years earned a steady living from the sale of such pictures, (and, equally important, steel engravings after them) with subjects like *Beating for Recruits* (boys at play inviting a companion who has been left in charge of a sleeping baby to join them (PLATE 24)). A more sombre childhood theme is seen in *Sickness and Health* of 1843 (PLATE 25), in which the sick girl, to whom her brother has been reading, is diverted by watching children dance to the music of an itinerant Italian hurdy-gurdy player. This theme of child sickness and mortality was of course of particular interest in those days of high infant mortality to a public which wept over Charles Dickens's treatment of such affecting scenes as the death of Little Nell in *The Old Curiosity Shop* (1841), and the slow illness and decline of Paul Dombey in *Dombey and Son* (1848).

A more cheerful treatment of childhood was provided by the work of another member of the group, Frederick Daniel Hardy (1826–1911). Hardy specialised in scenes depicting children engaged in adult activities, with such titles as *The Young Photographers*, 1862 – an amusing glimpse of the children of a photographer pretending to take a *carte de visite* likeness. *Playing at Doctors* (PLATE 26) painted the following year shows a doctor's children imitating their Papa by making up pills, taking pulses, and pounding up medicines in a mortar, while through the open doorway can be seen their grandmother returning to this alarming scene. The painting, so full of diverse anecdote, is brilliantly successful in avoiding obvious humour because Hardy firmly and unpretentiously conveys a feeling of actuality, of surroundings which create the illusion of a specific sense of place. These qualities can also be seen in some of the artist's small still-life studies of virtually empty room interiors in the humble cottages around Cranbrook. They are intensely realised because he knew them so well.

J. C. Horsley (1817–1903), another member of the

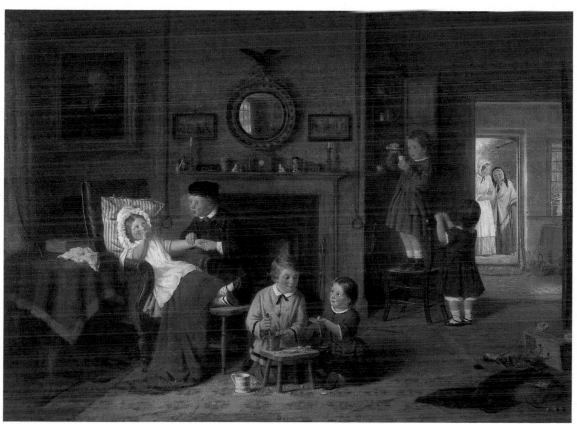

27

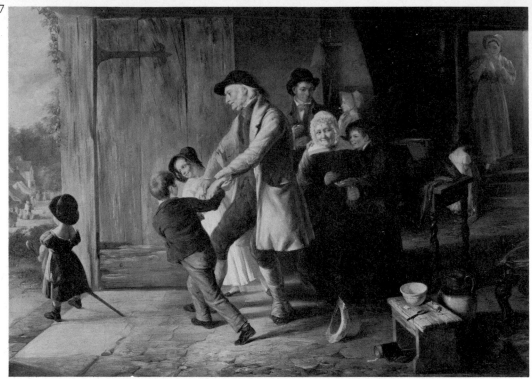

28

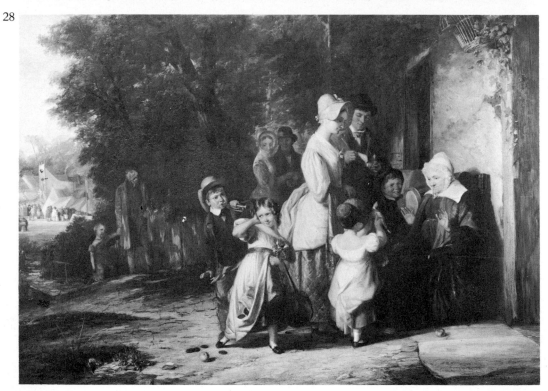

PLATE 27
Thomas Webster R.A.
Going to the Fair
Signed T. Webster 1837
Exhibited B.I. 1838
Panel 22 × 30 in (55 × 75 cms)
F.A.220
Sheepshanks Gift
Webster's two studies of the pleasures aroused by a rural
fair possess the narrative element common to all such
paired subjects, one of the most frequently used devices
of the Victorian genre painter. This 'before' and 'after'
narrative form was used to great effect by artists as
various as Abraham Solomon whose *Waiting for the
Verdict* shown at the R.A. in 1857 was followed in 1859
by its sequel *Acquitted* and Sir John Everett Millais with
his *First and Second Sermon* showing a little girl in church,
wide awake and then asleep.

PLATE 28
Thomas Webster R.A.
Returning from the Fair
Signed T. Webster 1837
Exhibited B.I. 1838
Panel 22 × 30 in (55 × 75 cms)
F.A.221
Sheepshanks Gift

PLATE 29
John Callcot Horsley R.A.
The Contrast, Youth and Age
Signed J.C.H. 1839
Exhibited R.A. 1840
Panel 18 × 16 in (45 × 40 cms)
F.A.81
Sheepshanks Gift

29

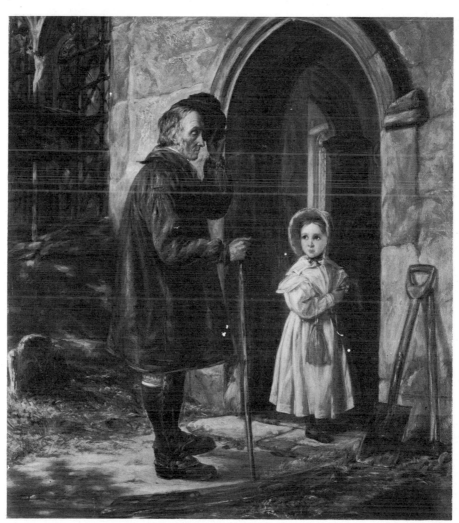

30

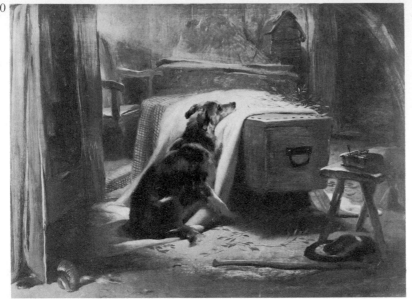

31

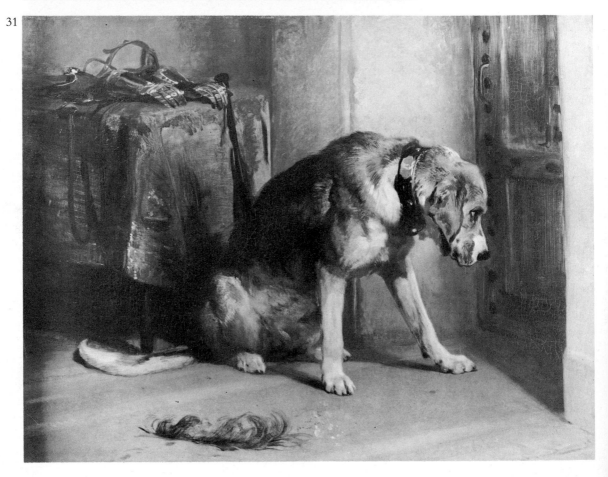

group, was nick-named 'Clothes Horsley' because he disliked the use of naked models in life classes at the Royal Academy, where in his later years he was instrumental in inaugurating the series of winter exhibitions of old-master paintings. His early work, for example· *The Contrast, Youth and Age* of 1839 (PLATE 29), has a direct charm which he lost in his later elaborate costume pieces. Such a painting shows the full extent to which Mulready's artistic preoccupations were shared and developed by his younger contemporaries, and the enthusiasm with which the theme of childhood and age was developed in the early nineteenth century. But there were of course, other equally popular themes, notably that of animal genre, a subject particularly associated with the work of Sir Edwin Landseer.

Sir Edwin Landseer and Animal Genre

Landseer's name immediately conjures up images of dogs with cold wet noses and shaggy coats, like the dog grieving for his dead master in *The Old Shepherd's Chief Mourner* of 1837 (PLATE 30) and the hound in *Suspense* of 1834 (PLATE 31), watching at the closed door of a room in which his wounded master lies bleeding. Of these paintings a late Victorian critic wrote: 'The pathos of these poor creatures is that they are entirely *doggy* . . . the dog losing his master loses his all', while John Ruskin described *The Old Shepherd's Chief Mourner* as 'one of the most perfect poems or pictures . . . which modern times have seen'.

Although it was painting dogs which brought him fame, Landseer also produced other genre subjects, such as his early *The Stonebreaker and His Daughter* of 1830 (PLATE 32). The theme was a topical one, for since the late eighteenth century the road system of the country had been transformed by the work of Telford and Macadam, improvements accomplished not with sophisticated modern earthmoving techniques but by the back-breaking labour of stonebreakers and navvies.

In the painting Landseer skilfully contrasts the physical exhaustion of the man seated on the ground, (his ram's horn full of snuff beside him and his rough-haired terrier for company) with his pretty daughter who has brought him his lunch in a basket. She looks down at her father compassionately while the dog nuzzles her head. In the distance the smoking chimneys of the crofter's cottage hint at the favourite early nineteenth-century moral theme of happy domesticity in rural poverty extolled by Robert Burns in such lines as:

> The honest man, though e'er sae poor,
> Is king o'men for a'that.

The subject of stonebreaking – manual labour at its most exhausting – was to be used again in 1857 by the Pre-Raphaelite painters John Brett (1830–1902) and Henry Wallis (1830–1916) in two contrasting works, and most notably in France by the great romantic realist painter Gustave Courbet (1819–1877) in a controversial work of 1851. Landseer's

PLATE 30
Sir Edwin Landseer R.A. (1802–1873)
The Old Shepherd's Chief Mourner
Exhibited R.A. 1837
Panel 18 × 24 in (45 × 60 cms)
F.A.93
Sheepshanks Gift

PLATE 31
Sir Edwin Landseer R.A.
Suspense
Exhibited B.I. 1834
Panel 27½ × 35¾ in (69 × 89 cms)
F.A.99
Sheepshanks Gift

PLATE 32
Sir Edwin Landseer R.A.
The Stonebreaker and His Daughter
Panel 18 × 23 in (45 × 58 cms)
508–1882
Jones Bequest

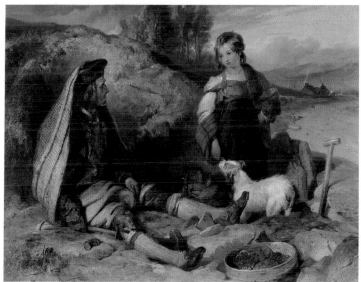

32

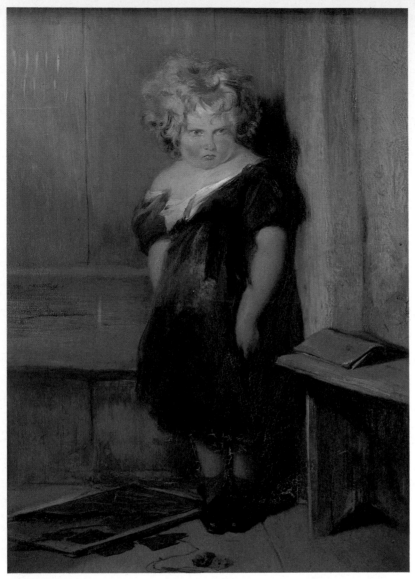

painting, with its emphatic sentiment, belongs firmly to the older genre tradition, though it might be described as a proto-realist work. As in all his work, the sheer quality of his handling of paint gives much visual pleasure, both in the brilliantly observed still-life elements of stones, sieve, hammers and spade, and in the depiction of the stonebreaker himself; the latter incidentally anticipates the portrait studies of Highland gillies he later painted for Queen Victoria.

Landseer also turned his hand to other genre subjects in these early years before he completely devoted himself to animal painting. In 1834 he achieved

great success with *The Naughty Child* (PLATE 33) with its candid treatment of one of the most trying aspects of childhood. The same year he exhibited *Highland Breakfast* (PLATE 34) which successfully combined dogs with a human subject of great appeal. An anonymous reviewer in *The Athenaum* commended the painting for its depiction of 'the group of terriers and hounds . . . socially toiling with their teeth . . . [and the] young mother giving her child the breast . . . the innocence of the latter and the truth to nature of the former are equally striking'.

But while these paintings show the wide range of

Landseer's abilities it was subjects like his Academy success of 1839, *A Jack in Office* (PLATE 35), that really made his name familiar to a wide public. This work, one of his most clearly anthropomorphic treatments of human life in canine terms, shows a terrier guarding his master's meat cart from the attention of other dogs, the scales between his paws providing an ironical allegorical reference to justice. The dog in the cart is a Jack Russell terrier, depicted as being considerably overweight to emphasise the point of the title. Two years later, as so often happens, life imitated art, when the Conservative administration fell, and 'Jack', Lord John Russell, became Leader of the House of Commons, Home Secretary and thus a dispenser of patronage. The event produced a witty squib from the caricaturist 'H.B.' – John Doyle (1797–1868). He used Landseer's composition, with Lord Brougham, hungry for office, satirised as the whining pointer bitch, sniffing at the meat, O'Connell sitting up and begging as a poodle, and the formidable Lord Durham

34

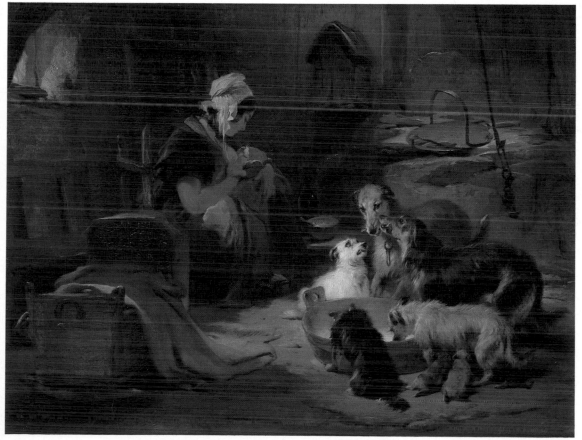

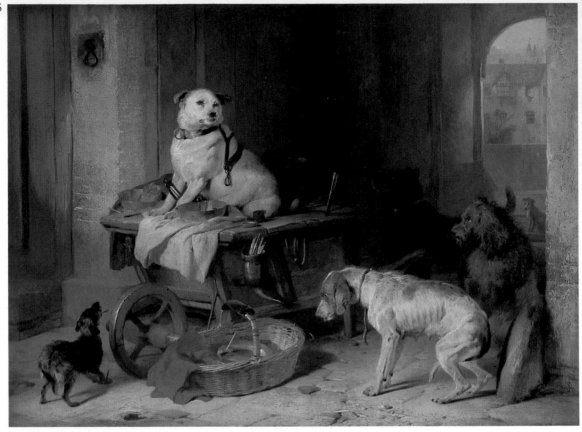

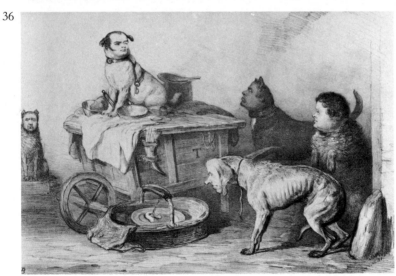

PLATE 35
Sir Edwin Landseer R.A.
A Jack in Office
Exhibited R.A. 1839
Panel 19¾ × 26 in (49 × 65 cms)
F.A.94
Sheepshanks Gift

PLATE 36
John Doyle
Caricature of 'A Jack in Office' by 'HB'

PLATE 37
Sir Edwin Landseer R.A.
*The Drover's Departure – A Scene
in the Grampians*
Exhibited R.A. 1835
49½ × 75¼ in (124 × 188 cms)
F.A.88
Sheepshanks Gift

as the alert terrier in the background (PLATE 36).

Landseer's wide-ranging talents could encompass both the powerful study of Highland life in *The Drover's Departure* of 1835 (PLATE 37), and the mawkish sentiment of *Be It Ever So Humble There's No Place Like Home* of 1842: a canine comment on the 'hungry forties'.

After his death, Queen Victoria wrote the following tribute in her diary to 'her kind old friend': 'How many an incident do I remember, connected with Landseer! He kindly has shown me how to draw stag's heads, and how to draw in chalks, but I could never manage that well. I possess thirty-nine oil paintings of his, sixteen chalk drawings (framed), two frescoes, and many sketches.'

The Victoria and Albert Museum also has a large collection of his work, twenty-one oils and many drawings, which reveal the pure painterly qualities of his style. These works show that there is infinitely more to Landseer's achievement than a 'dog phase', followed by a 'stag phase' culminating in the 'lion period' in which he created the great recumbent beasts that guard the base of Nelson's column in Trafalgar Square.

Recurrent Themes: the Vision of Italy

In a letter to his brother Zechariah from Naples in 1825, Thomas Uwins (1782–1857) wrote of the inspiration that Italy had given him as an artist:

> There is one point, in which Italy in an artist's eye must always have the preference – I mean the school it affords for study; and in this I do not refer merely to the pictures, statues and works of art with which it abounds, but to the simplicity of the manners of the people, the rudeness of their instruments of husbandry and labour, and the historic character of their features and their dress In England a painter must invent everything, so much in opposition do the refinements of modern dress and the discoveries of modern science stand to those manners and those times which he is constantly called upon to represent. In Italy, on the contrary, the thing is half made up to his hand.

Uwins's testimony could be echoed by many other British artists for whom Italian themes offered a fruitful field throughout the nineteenth century.

Uwins specialised professionally in Italian genre subjects such as *A Neopolitan Saint Manufactory*, and

38

39

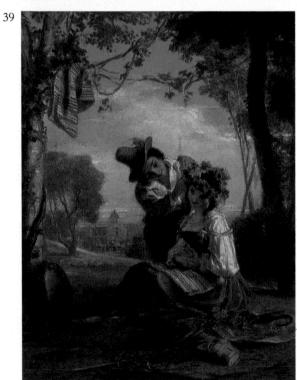

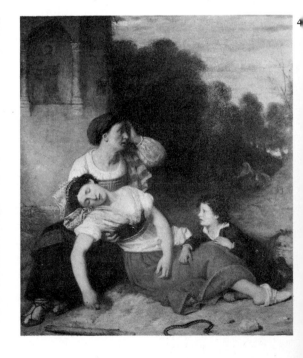

34

PLATE 38
Thomas Uwins R.A.
An Italian Mother Teaching Her Child the Tarantella
Signed and dated on the back Thos. Uwins R.A. 1842
Panel 17 × 22 in (42.5 × 55 cms)
F.A.213
Sheepshanks Gift
(Such was the popularity of this picture that it was used
as a design for wallpaper.)

PLATE 39
Thomas Uwins R.A.
*A Neopolitan Boy Decorating the Head of His Inamorata at
the Festa of the Madonna del Arco*
Exhibited R.A. 1840
Panel 14 × 10½ in (35 × 26 cms)
F.A.214
Sheepshanks Gift

PLATE 40
Sir Charles Lock Eastlake P.R.A.
Peasant Woman Fainting from the Bite of a Serpent
Signed C. L. Eastlake 1831
Exhibited R.A. 1831
22 × 18¾ in (55 × 47 cms)
F.A.70
Sheepshanks Gift

PLATE 41
Edward Villiers Rippingille (1798–1859)
Mendicants of the Campagna
Signed EV Rippingille Roma 1840.
London 1844
14½ × 22½ in (36 × 56 cms)
F.A.173
Sheepshanks Gift

such ever-popular titles as *Brigands Capturing English
Travellers* and *Nuns Taking the Veil*; with their ro-
mantic *frissons* they became virtually his stock in
trade. In 1838 when elected R.A. he wrote, 'The
public have chalked out a course for me; because I
have done some Italian subjects successfully, no one
will have anything else from my hand, and they who
"live to please, must please to live".' Certainly his
An Italian Mother Teaching her Child the Tarantella of
1842 (PLATE 38) pleased the Victorian public; so much
so that no less than six repetitions of the picture
from his hand are recorded. Intriguingly the initial
idea for this painting came to him not from actual
observation in Italy, but at one of the meetings of
the Sketching Society to which he belonged (on 2nd
April, 1831). Another attractive example of Uwins's
work is his *A Neopolitan Boy Decorating the Head of
His Inamorata* of 1840 (PLATE 39).

For Sir Charles Lock Eastlake (1793–1865), resi-
dence in Rome from 1818 to 1830 provided him
with an opportunity to acquire the deep knowledge
of Italian Renaissance art which later made him a
distinguished Director of the National Gallery.
While in Rome he worked first as a landscape painter
before turning to genre subjects, scoring a notable
success with *Pilgrims in Sight of Rome and St. Peters,
Evening* of 1827, a subject which he repeated five
times. He also found themes in the life of the Roman
Campagna, and painted them in works such as *Peas-
ant Woman Fainting from the Bite of a Serpent* of 1831
(PLATE 40).

Models were provided by the ever-changing cast
of picturesque characters who thronged the Spanish

41

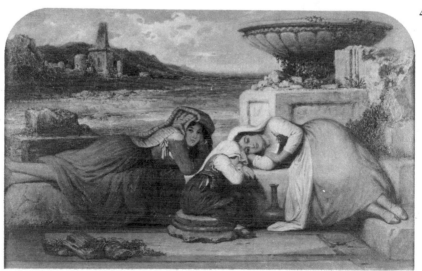

Steps in Rome, the centre of the artists' quarter, inhabited by painters from all over Europe. *Mendicants of the Campagna* (PLATE 41) by Edward Villiers Rippingille (1798–1859) shows some attractive peasant girl models in a carefully posed studio composition begun in Rome in 1840 and finished in London in 1844. In a note attached to the back of the frame the artist noted that when the picture was first exhibited it was virtually unnoticed by the public as it was hung only a few inches from the floor; a vivid reminder of the crowded walls of the Victorian Royal Academy, and the importance of a picture being hung 'on the line'*.

Paintings such as these provided the annual exhibitions of the Royal Academy with a welcome change from the more familiar productions of artists working in the prevailing fashion of domestic subjects. There were of course specialists in picturesque genre scenes from other equally exotic lands, notably John 'Spanish' Phillips, and the Middle Eastern subjects of John Frederick Lewis, now again enjoying a fashionable vogue. For the Victorian patron the acquisition of such works, (before the 'Napoleon of Excursionists', Thomas Cook, made foreign travel relatively easy in the 1860s) provided, if not the actual experience, at least the vicarious pleasure of foreign travel.

Recurrent Themes: the 'Frailer Sex'

The treatment of the role, or plight, of women in early nineteenth-century painting, is, on the whole, liable to confirm the fears of those sensitive to sexism that most male attitudes of that period were chauvinist. If not depicted as happy wives and responsible mothers, women were often shown as the victims of rejected love or as exploited wage slaves. When such pictures are seen, however, as documentary evidence of the major emotional concerns of their age they take on a more impressive range and power. C. W. Cope's *The Young Mother*, 1845 (PLATE 42), emerges as far more than a conventional essay on the theme of maternity when its subject is viewed against the background of the alarming incidence of death in childbirth through the ravages of puerperal

*The line was a ledge 2 in (51 mm) deep which ran round the walls in the earlier homes of the Academy at Somerset House and Trafalgar Square, at a height of 8 ft (2.44 m) from the floor. All large pictures were 'above the line', the weight of the largest being supported by the ledge. Thus the best position was 'on the line'—immediately below the ledge, at, or just above, eye level; a contributory factor to the smaller average size of paintings in the second quarter of the nineteenth century. When the Academy moved to its present home Burlington House in 1869 the line was abolished and larger pictures again became fashionable.

fever. *An Anxious Hour* by Alexander Farmer, 1865 (PLATE 43), assumes a deeper significance when the figures of infant mortality through typhoid fever are remembered, and takes a useful place in the countless nineteenth-century treatments of this theme by artists as varied as Sir Luke Fildes and Edvard Munch.

The same process of reappraisal in the light of the emotive concerns of the age is valuable when considering a key work of the English Romantic movement like Francis Danby's *Disappointed Love* of 1821 (PLATE 44). This, his first exhibited painting at the Royal Academy, is closely related in its mood of tragedy and despair to the work of the great Romantic poets, Keats, Shelley and Byron. A contemporary reviewer commented on the 'deep, gloomy and pathetic influence [which] pervades the picture of this artist'.

John Sheepshanks once showed the picture to Lord Palmerston, who commented favourably on the deep gloom of the scene conveyed so vividly through the trees and vegetation, but remarked that it was a 'pity the girl was so ugly'. 'Yes,' replied Sheepshanks, 'one feels that the sooner she drowns herself the better. She always reminds me of the reply made by a hard-hearted judge, who, on the northern circuit, had tried a girl for killing her child. Some lady who was deeply interested in the young women's fate met the judge at dinner and ventured

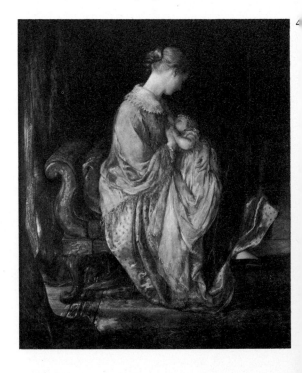

PLATE 42
Charles West Cope R.A. (1811–1890)
The Young Mother
Signed and dated 1845
Panel 12 × 10 in (30 × 25 cms)
F.A.53
Sheepshanks Gift

PLATE 43
Alexander Farmer (?–1869)
An Anxious Hour
Signed and dated Alexr Farmer 1865
Panel 12 × 16 in (30 × 40 cms)
541–1905
Bequeathed by Miss Emily
Farmer R.I.

PLATE 44
Francis Danby A.R.A. (1793–1861)
Disappointed Love
Exhibited R.A. 1821
Panel 20¾ × 32 in (62 × 80 cms)
F.A.65
Sheepshanks Gift

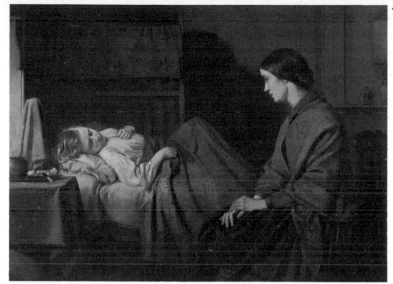

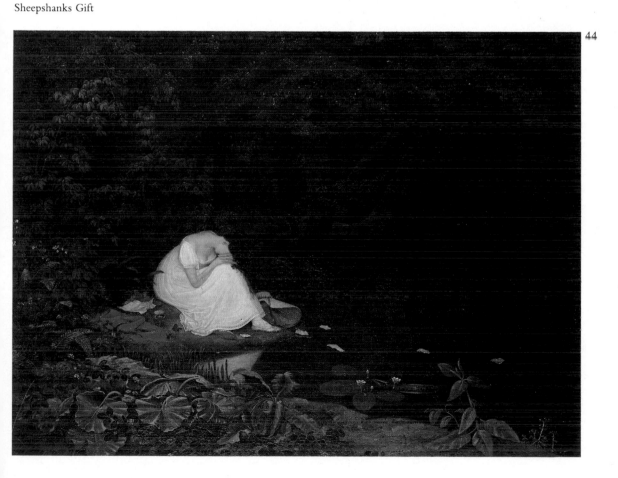

44

to say imploringly 'Did he mean to leave the poor girl to be hanged?' 'Hanged, Madam!' said the irritated judge, 'Certainly; what else is she fit for? She is so confoundedly ugly!'

This appallingly cynical story might well unfairly prejudice our opinion of Sheepshanks's sensibilities, but like many cynics he had a sentimental side, and this could at times affect this reaction to works which he commissioned, and lead him to ask for details of their composition to be changed by the artist. He saw and admired a painting *The Poor Teacher* by Richard Redgrave (1804–1888), and commissioned another treatment of the same theme. But on receiving it, Sheepshanks objected to the terrible loneliness of the forlorn governess in the empty room, and on his request Redgrave added the playing children seen through the doorway. The painting was exhibited in the Royal Academy in 1845 with the title *The Governess – 'She sees no kind domestic visage near'* (PLATE 45), the sentiment of the title being emphasised by the words of the music on the piano *Home, Sweet Home*, the ballad popularised by Jenny Lind, the 'Swedish Nightingale'. The tears in the Governess's eyes, the black-edged paper of the letter she holds, her full mourning dress, and even the thin, dry toast on the plate, underline the pathos of her position, and contrast with the privileged happiness of the girls in the loggia beyond.

It is all too easy to cite this picture, and Redgrave's Royal Academy Diploma work which shows a young unmarried mother and her baby being thrown out into the snow by her family, as expressions of the worst aspects of Victorian sentimentality. But Redgrave was far more than a mere sensationalist; he was an art historian and critic of rare discrimination who as Art Referee played a vital part in building up the collections of paintings at South Kensington. His work should be judged by the criteria of its own times, and it can then be seen as a far from trivial expression of a sensitive man's reaction to dilemmas which confronted the alert social conscience of the period. *The Governess* takes its place as a social document alongside Charlotte Brontë's *Jane Eyre* and other works concerned with the role of women in a male-dominated society by writers as diverse as John Stuart Mill and Charles Dickens.

45

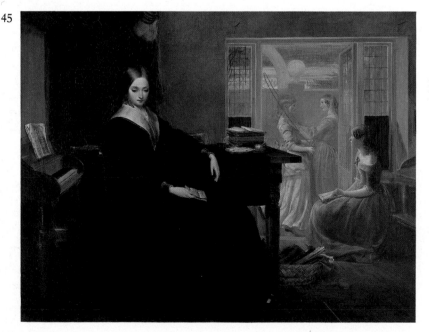

PLATE 45
Richard Redgrave R.A.
The Governess – 'She sees no kind domestic visage near'
Signed Richd Redgrave, 1844
Exhibited R.A. 1845
36 × 28 in (90 × 70 cms)
F.A.168
Sheepshanks Gift

PLATE 46
William Powell Frith R.A. (1819–190*
Dolly Varden
from Charles Dickens, *Barnaby Rudge*
Signed W. P. Frith 1842
21½ × 17½ in (53 × 44 cms)
F.8
Forster Bequest

Recurrent Themes: Literary Subjects

In 1786 John Boydell, then Alderman and later Lord Mayor of London, conceived the idea of helping Britain acquire a school of history painting, declaring no subject seemed so proper to form an English School of Historical Painting as the scenes of the immortal Shakespeare. In a gesture combining altruism and commercial interest Boydell commissioned paintings from thirty-five artists, and a gallery in Pall Mall, hoping to recoup his expenditure by the sale of engravings after the works by artists as eminent as Reynolds, Romney and West. Unfortunately the enterprise which opened with great success in 1789, was soon blighted by the war and the activities of commercial imitators, and in 1804 Boydell dispersed the collection by lottery to avoid bankruptcy proceedings.

Boydell's Shakespeare Gallery, and Fuseli's Gallery of the Miltonic Sublime, founded in 1799, were both symptomatic of the close relationship that has always existed in England between literature and painting. In the early nineteenth century paintings on literary subjects were to provide narrative painters with some of their most consistently lucrative themes. By purchasing such a work the patron could both demonstrate the high level of his own cultural background to his guests and be diverted by an amusing and colourful costume piece, since the subjects portrayed came almost invariably from classic works of earlier times.

The most popular English authors for pictorial treatment were, in a rough order of descending popularity, Shakespeare, Goldsmith, Sterne, Scott, Burns and later Dickens, with Cervantes, Molière and Le Sage being the most favoured foreign writers. These names now strike us as presenting a rather curious order of popularity. Shakespeare, Cervantes and Molière we can understand, but some of the other names surprise us; who now, outside a university, reads Le Sage's *Gil Blas*? Goldsmith too would not now be rated so highly but for the early nineteenth-century public his play *She Stoops to Conquer* was ideal for family theatre visits or amateur production, and his works were eminently suitable for reading in the domestic circle. Indeed, so popular did Goldsmith's works become as a pictorial source for academic painters that W. M. Thackeray, whose little-known art criticism in the *Roundabout Papers* is a valuable guide to early Victorian taste, threatened to refuse to review any more paintings on these themes, although his good resolution was broken when he saw and admired two scenes from *The Vicar*

of Wakefield by William Mulready in the Academies of 1844 and 1847. Mulready was of course an established favourite, and W. P. Frith's *Measuring Heights* of 1842 (PLATE 48) from Chapter 16 of *The Vicar of Wakefield* may be taken as characteristic of the more pedestrian works inspired by Goldsmith's novel, although even more clichéd treatments exist by artists like Abraham Solomon.

Frith, born in Harrogate in Yorkshire, had, as a boy, wanted to be an auctioneer rather than an artist, and was always keenly aware of the commercial possibilities of his works. His early career as a painter was devoted to literary subjects which illustrated the foibles of human nature, and he turned his hand with equal facility to Sterne, Scott, and, later, Dickens. *Dolly Varden* (PLATE 46) of 1842 from Dickens's eighteenth-century period novel *Barnaby Rudge* which dealt with the Gordon Riots is perhaps his most successful work of this type, and was repeated no less than six times.

Less well known are his scenes from Molière's play *Le Bourgeois Gentilhomme* (PLATE 49)*. This play was immensely popular as an artistic subject in the 1830s and 1840s, a period which saw the emergence

*Curiously there appears to be no record of the play being produced at the time, although there is a slight resemblance to the well-known comic actor Jack Bannister in some of these portrayals of M. Jourdain.

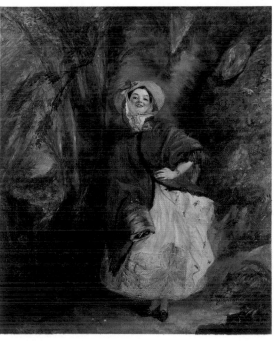

46

47

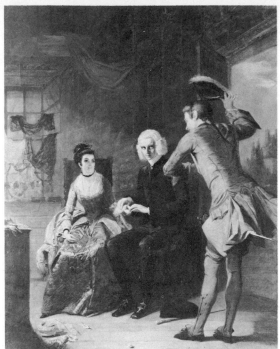

PLATE 47
William Powell Frith R.A.
Scene from *A Sentimental Journey* by Lawrence Sterne
Signed W. P. Frith 1841
35½ × 27½ in (89 × 69 cms)
556–1882
Jones Bequest
Sterne's novels were rich quarries of anecdotal situations
of arch human interest, like this incident of Sterne taking
the pulse of the pretty glove seller, which provided Frith
with an ideal opportunity for the painstaking costume
reconstruction that first brought him fame before he
turned to scenes of contemporary life.

PLATE 48
William Powell Frith R.A.
Measuring Heights
from Oliver Goldsmith, *The Vicar of Wakefield*
Exhibited R.A. 1842
Panel 9 × 12 in (22 × 30 cms)
511–1882
Jones Bequest

48

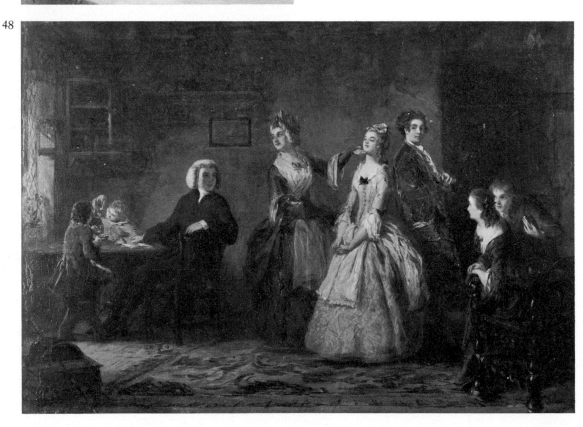

PLATE 49
William Powell Frith R.A.
From *Le Bourgeois*
Gentilhomme by Molière Act III Scene xvi
Signed W. P. Frith 1860
12½ × 22 in (31 × 44 cms)
537–1882
Jones Bequest

PLATE 50
Charles Robert Leslie R.A.
(1794–1859)
From *Le Bourgeois Gentilhomme*
by Molièrc Act III Scene iii
Exhibited R.A. 1841
25 × 38½ in (60 × 96 cms)
F.A.116
Sheepshanks Gift

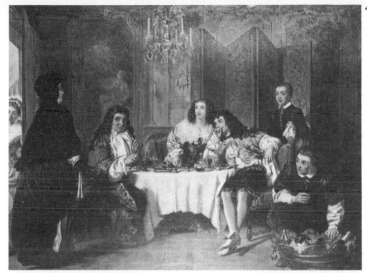

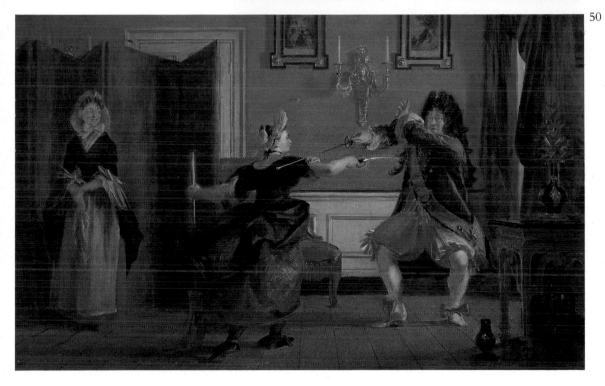

of a large new middle class of successful manufacturers. Molière's Monsieur Jourdain, the quintessential *nouveau riche* figure could be readily appreciated in an age which saw the emergence of such speculators as Hudson, the 'Railway King' of York, and it is therefore not surprising to find him also appearing in some of the liveliest of C. R. Leslie's works (PLATE 50).

Charles Robert Leslie (1794–1859) was by temperament and ability ideally suited to excel at literary subject painting, of which he was the greatest exponent. Born in London, he spent his earl youth in Philadelphia, and he always seems to have retained a good measure of easy-going American charm. He must have possessed this quality to an unusual degree, as without it he could hardly have achieved close personal friendships with figures as diverse as the Redgrave brothers (the art historians) and the touchy John Constable. This latter friendship was to enable him to write the famous *Memoirs* of the great landscape painter for which he is now, perhaps, chiefly remembered.

Leslie, as the Redgraves shrewdly remarked, realised early in life that the true bent of his genius was for comedy. Humour is always liable to date more quickly than any other quality in a work of art, and for that reason some of his works are difficult to appreciate today. But his *Autolycus* of 1836 (PLATE 51) is one of the finest of all pictorial treatments of Shakespeare in English art, and the gentle humour of *My Uncle Toby and the Widow Wadman* of 1832 (PLATE 52) has all the continuing validity of Sterne's ironic masterpiece *Tristram Shandy*. When he turned to more personal subjects, Leslie's talents are seen at their best, as in the study of his infant son at play in the back garden of his Edgware Road home in London—one of the most delightful of all Victorian depictions of childhood, freshly observed, and not overlaid with any conscious attempts at winsome charm (PLATE 53).

PLATE 51
Charles Robert Leslie R.A.
Autolycus from Shakespeare,
The Winter's Tale, Act IV Scene iv
Exhibited R.A. 1836
21 × 29 in (52.5 × 72.5 cms)
F.A.115
Sheepshanks Gift

51

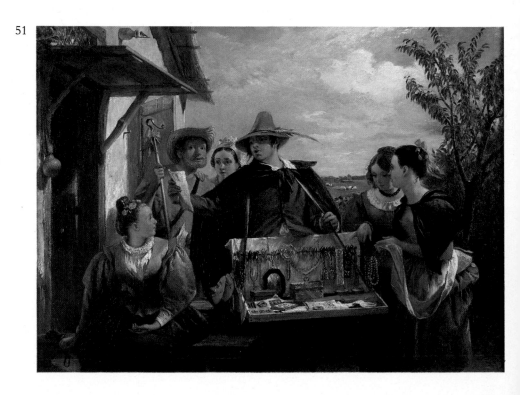

PLATE 52
Charles Robert Leslie R.A.
My Uncle Toby and the Widow Wadman
from Lawrence Sterne, *Tristram Shandy*
Painted 1832
32½ × 22½ in (81 × 56 cms)
F.A.113
Sheepshanks Gift
This was Leslie's most famous composition, which he
repeated several times. The light comic actor John
Bannister was the model for Uncle Toby. The picture
became extremely well known as an advertising image in
the 1860s. It was reproduced as a polychrome transfer
print on the lids of pots, issued by F. & R. Pratt,
containing Russian Bear's Grease (gentleman's hair
dressing) and it is not too fanciful to imagine a Victorian
'Widow Wadman' giving such a pot to her 'Uncle Toby'
during their courtship.

PLATE 53
Charles Robert Leslie R.A.
A Garden Scene – portrait of the youngest son of the artist
with his toys.
12 × 16 in (30 × 40 cms)
Γ.Λ.130
Sheepshanks Gift

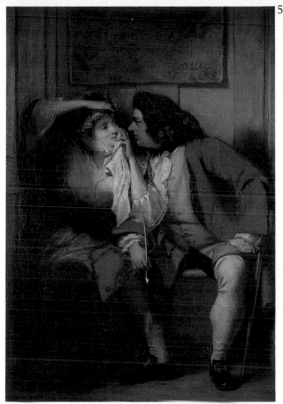

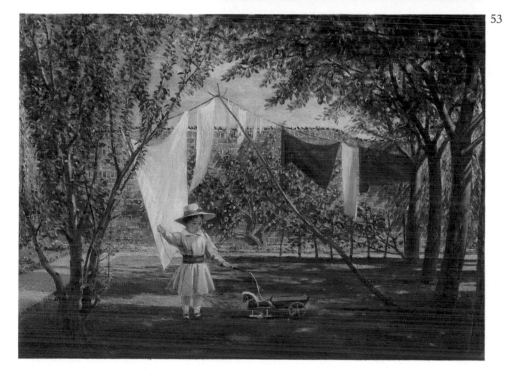

54

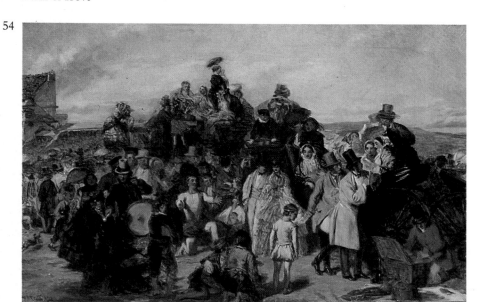

54a

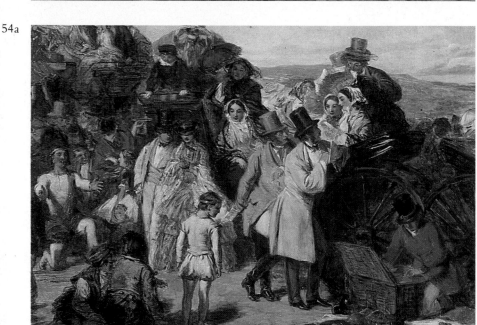

William Powell Frith's Derby Day

Frith's early success as a painter of literary subjects illustrating the foibles of human nature gave place in 1851 to his first major success on the broader stage with his painting *Life at the Seaside – Ramsgate Sands*. The purchase of the picture by Queen Victoria for the Royal Collection, and its subsequent widespread fame as an engraving, showed the appetite of the Victorian public for microcosms of contemporary life; Frith, always alert to the demands of public taste, sought for another theme which could provide an opportunity for depicting a wide cross-section of human life. This was provided by the annual 'English Carnival' at Epsom Downs on Derby Day.

Frith's first visit to a race meeting, the long defunct minor course at Hampton, was a memorable one. He watched with amusement some gypsies eating a Fortnum and Mason pie, and with horrified fascination saw an unsuccessful gambler try to cut his throat. 'The idea occurred to me that if some of the salient points of the great gathering could be grouped together, an effective picture might be the result', he wrote in his autobiography. His lady companion, to whom he mentioned the idea, replied 'that it was impossible to represent such an enormous crowd on canvas, without producing confusion worse confounded'. Frith no doubt regarded this as a challenge, and *Derby Day* is his triumphant answer (PLATE 55).

His first visit to the Derby took place in 1856. He wandered round the course with his friend, the genre painter Augustus Egg, who had difficulty in restraining Frith from losing all his money to a 'thimble rigging' gang. This game, in which the victim tries to guess which of three thimbles conceals a pea, forms the main incident on the left of *Derby Day*.

Frith was fascinated by the diversity of life and character at the Derby. 'The acrobats with every variety of performance, the nigger minstrels, gipsy fortune-telling, to say nothing of carriages filled with pretty women, together with the sporting element . . . the more I considered the kaleidoscopic aspect of the crowd on Epsom Downs the more firm became my resolve to represent it.' He was undaunted by the compositional problems involved. 'I cannot say I have ever found a difficulty in composing great numbers of figures into a more or less harmonious whole. I don't think this *gift* or *knack* can be ac

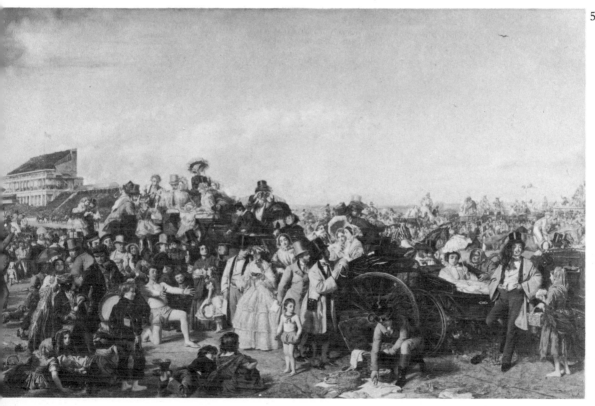

56

57

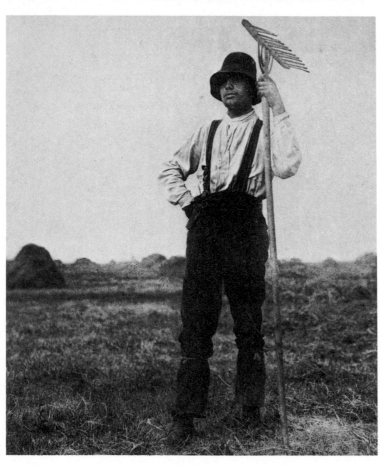

quired And granting the facility, too much time can scarcely be spent in making preliminary studies, always from nature, of separate figures and groups.'

In the next fifteen months he devoted all his energies to these studies, having first decided on the principal incident of the picture: the hungry child acrobat distracted from his performance by the unpacking of a sumptuous picnic hamper by a groom. This is the incident depicted in plate 54, one of the many studies which Frith made for the final painting now in the Tate Gallery.

When the completed picture was shown at the Royal Academy in May 1858 the painting was an instant popular success, but this was not accompanied by equal critical acclaim. Ruskin, while agreeing that 'It is quite proper and desirable that this English carnival should be painted', described the work as 'a kind of cross between John Leech [the *Punch* caricaturist] and Wilkie, with a dash of daguerreotype here and there, and some pretty seasoning of Dickens' sentiment'.

While Ruskin's apt summary has the perceptiveness which informs so much of his criticism, it is more fitting to conclude this brief glance at one of the greatest of all genre paintings with Sickert's words. He considered the picture 'as full of surprises as an Easter egg', and 'certainly, humanly speaking, one of the great victories over death'. This statement perhaps accounts for the picture's continuing hold over us today, and indeed, can be extended to explain the continuing spell which Victorian genre painting casts over us. For in these works we find reflected the attitudes of bygone eras to the comedy of human life, ever changing yet ever the same.

Genre painting was of course as popular abroad as in this country. Each of the themes discussed here can be paralleled in the Continental schools. The childhood scenes by the Swiss painters Menn, Hornung and Vautier; Fredrich Gauermann's humanised animals; Charles Baugniet's *Seamstress;* and Julius Schrader's *Italian Women in a Vineyard* (which form another fascinating aspect of Sheepshanks's collecting activities) provide very close comparisons with the work of Collins, Landseer, Redgrave and Uwins discussed above.

However Frith's *Derby Day* provides a fitting point at which to break off this survey. Genre painting continued to take on new and varied forms, notably in the work of the Pre-Raphaelites, and particularly in the paintings of Sir John Everett Millais.

Photography was also to emerge as a powerful rival to the genre painter's role of depicting the ordinary man and woman. Two works may be cited which perfectly express this confrontation and can fittingly end this essay: Thomas Armstrong's *The Hay Field* of 1869 (PLATE 56) and P. W. Emerson's *Life and Landscape on the Norfolk Broads* of 1882 (PLATE 57). The dichotomy between the real and the ideal has continued to dominate the genre impulse from the 1880's to the present day.

Further Reading and Viewing

By far the best method of learning about a painter's work is to read his own words, or those of contemporary writers and fortunately two of the major artists discussed in this essay left extensive autobiographies. These are W. P. Frith *My Autobiography and Reminiscences* (Two vols.) London, 1887, and *Further Reminiscences*, 1888. Although gossipy, and full of irrelevant digressions, they still remain an indispensable introduction to the work of this great chronicler of day to day life in the Victorian age.

C. R. Leslie's *Autobiographical Recollections* (Two vols.) London, 1860, reveals the charm which made him so liked a figure, and throws much light on his contemporaries and the workings of the Royal Academy. C. H. Cope's book on his father is also worth reading, *Reminiscences of Charles West Cope R.A.*, 1891.

Equally important, and an invaluable general survey of all the artists reviewed in this essay, is Samuel and Richard Redgrave's *A Century of British Painters* first published in 1866, latest edition, edited by Ruthven Todd, Phaidon, 1947.

Some other valuable contemporary works of criticism are John Ruskin's *Academy Notes* which can be found in the complete Cook and Wedderburn edition of Ruskin's works, and W. M. Thackeray's art criticism in the *Roundabout Papers* in the complete library edition of his work, Oxford University Press.

Among secondary sources the following books will be found of value:

Quentin Bell, *Victorian Artists*, Routledge and Kegan Paul, London, 1967

Josephine Gear, *Masters or Servants?*, Garland, London and New York, 1977:
> a valuable study of genre painting and social attitudes from the mid eighteenth to early nineteenth century.

Kathryn Moore Heleniak, *William Mulready*, Yale University Press, New Haven and London, 1980

Hesketh Hubbard, *A Hundred Years of British Painting, (1851–1951)*, Longmans, London, 1951

Jeremy Maas, *Victorian Painters*, Barrie and Rockliff, London, 1969

Graham Reynolds, *Painters of the Victorian Scene*, Batsford, London, 1953 and *Victorian Painting*, Studio Vista, London, 1966

Sacheverel Sitwell, *Conversation Pieces*, Batsford, London, 1936 and *Narrative Pictures*, Batsford, London, 1937

Christopher Wood, *Dictionary of Victorian Painters*, 2nd Edition, Antique Collectors Club, Eastbourne, 1978

Catalogues:

The Victorian Vision of Italy, Leicester Museum and Art Gallery, 1967. Essays by L. Lambourne, L. Hermann and H. Miles.

Victorian Engravings, Victoria and Albert Museum, 1973, by Hilary Beck

The Cranbrook Colony, Wolverhampton Art Gallery, 1977, by Andrew Greg

Great Victorian Pictures, Arts Council, 1978, by Rosemary Treble

Derby Day, Royal Academy, 1979, by L. Lambourne and Pat Connor

Where to see them:

By far the best introduction to Victorian genre painting is to make an extensive tour of the great regional galleries of the Midlands and north of England. Birmingham, Leicester, Nottingham, Sheffield, Leeds, Manchester, Liverpool, Preston and many other towns have works which make the journey worthwhile. North of the border Aberdeen, Edinburgh's National Gallery, and Glasgow all contain notable paintings and, of course, particularly fine Wilkies. Bristol, and in the south of England, Tunbridge Wells, Brighton, Bournemouth, Southampton and the Royal Holloway College, Egham, have rewarding collections, the last named being of particular interest. In London the Victoria and Albert Museum, and Tate Gallery must be visited, and the salerooms and specialised dealers almost invariably have works of note.